Artlist Collection
THE DOG™

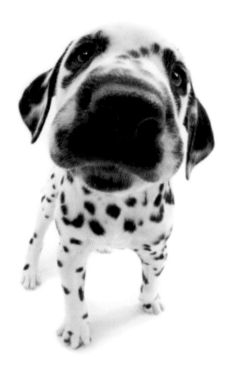

CARLTON
BOOKS

 INTRODUCTION

We are mean, cruel, heartless people – but that's the way we had to be. It was like walking through a home for lost dogs with the adoring eyes of a thousand puppies pleading, "Pick me! Please pick me and take me home with you! I'll be good. I'll always love you. I don't eat much. Please pick me!" Then you turn your back and the little tail stops wagging, the sparkle goes out of the eyes, the head droops and a sad little bundle of disappointment curls up slowly in the corner of a lonely cage. Okay, maybe selecting the photographs for this book wasn't quite that tough, but with over 100,000 pictures to choose from there were an awful lot that didn't make it onto these pages!

The images were all specially created for "The Dog" using "strange ratio" photography, an irresistibly cute new craze from Japan that started as a series of postcards in 2000 and grew into an entire industry using doggy pictures on everything from t-shirts and bedspreads to back packs and mobile phone covers. What makes the pictures so appealing is the way in which the photography works – they actually manage to make it look as if you've just got the dog home, he's come bounding up to welcome you and stuck his face as close to yours as he can get, so that you can give him a great big hug.

As this is the very first time "The Dog" image collection has appeared in book form, we have tried to show as many of the most popular breeds as possible but while you sigh and coo and ooh and aah over the pictures, do spare a thought for all the sad little bundles that were left behind!

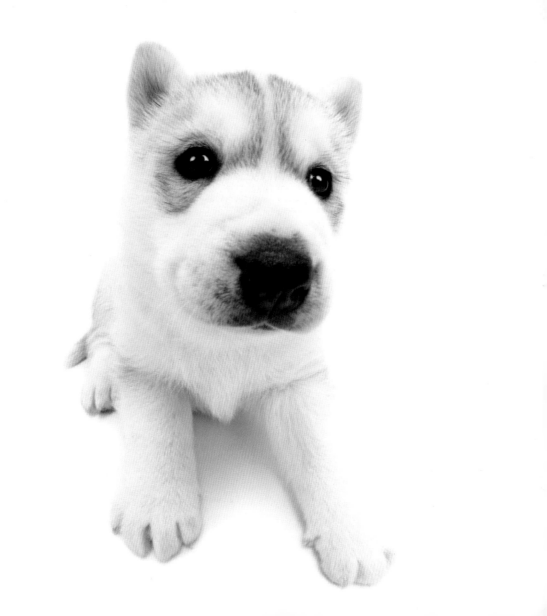

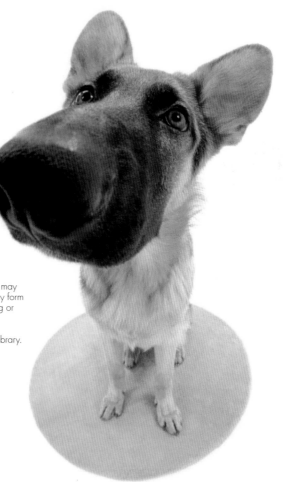

CARLTON
BOOKS

THIS IS A CARLTON BOOK
Published in 2010 by Carlton Books Limited
20 Mortimer Street
London W1T 3JW

10 9 8 7 6 5 4 3 2 1
The Dog Logo and Photographs © Artlist International Inc, 2010
Text & Design © Carlton Books Limited, 2010

A CIP catalogue record for this book is available from the British Library.

ISBN 978 1 84732 581 5

Printed in Dubai
Publishing Manager: Penny Craig
Executive Editor: Gemma Maclagan
Managing Art Editor: Lucy Coley
Designer: Barbara Zungia
Cover Design: Emily Clarke
Production: Karin Kolbe

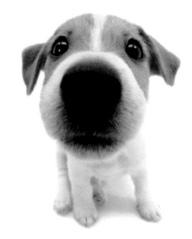

🏠 Contents

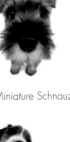

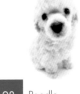

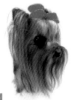

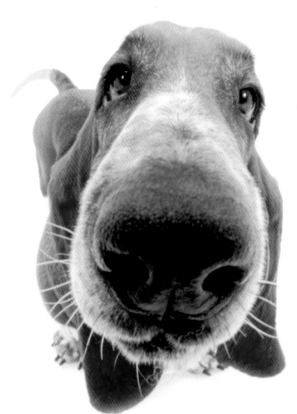

♪ *We used to hunt badgers, you know.*

BASSET HOUND

The Basset Hound's deeply wrinkled skin gives it the comical appearance of a small dog in a big dog's hand-me-down clothes. Despite the fact that this loose-fit look makes the poor Basset appear somewhat careworn, this is actually a happy, fun-loving breed of immense character. It also has a serious purpose in life as a tracker – being close to the ground allows it to put its impressive nose to good use. Basset Hounds originated in France in the sixteenth century, where they were prized as hunting dogs to seek out badgers. Their name comes from the French word *bas*, meaning low.

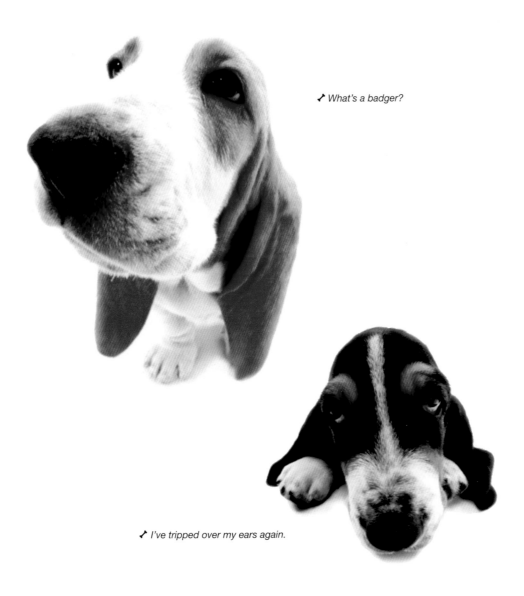

♪ What's a badger?

9

♪ I've tripped over my ears again.

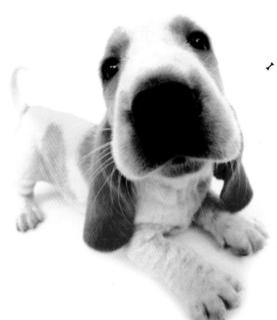

♪ You mean socks aren't meant to be chewed?

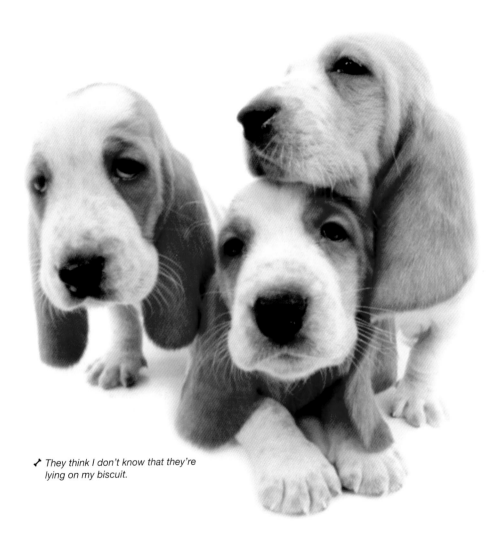

11

🦴 *They think I don't know that they're lying on my biscuit.*

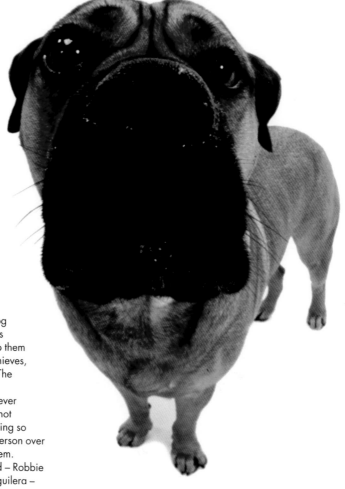

Stop frowning? But this is my best smile ...

BULL MASTIFF

A cross between the Old English Bulldog and English Mastiff, the Bull Mastiff was originally bred by gamekeepers to help them guard their estate from poachers and thieves, which led to the breed's nickname of "The Gamekeeper's Night Dog".

They are solid, muscular dogs but, never having been bred for hunting, they do not generally show signs of aggression. Being so powerful, however, they can knock a person over accidentally simply by running up to them.

They are an extremely popular breed – Robbie Williams has one, as does Christina Aguilera – and in the 1939 movie *The Hound of the Baskervilles* the hound in question was a large Bull Mastiff!

♪ Guarding things is so exhausting!

13

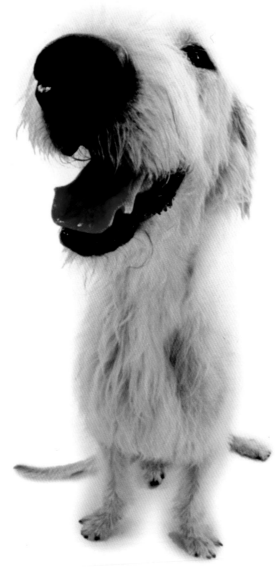

We're the tallest – see? Even sitting down.

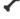

IRISH WOLFHOUND

The Irish Wolfhound is the tallest of the dog breeds. Their name gives a clue to their purpose and they were originally bred for speed, endurance and strength, three qualities needed in bringing down a wolf. They are huge, often the size of a small pony, but despite this they have a placid, easygoing nature and because they are so good with children, make ideal pets – if you can afford the food bills.

The ancestors of today's Irish Wolfhounds used to terrify the Ancient Romans when they first arrived on British shores but in truth, the breed makes terrible guard dogs because they are so friendly and affectionate, even with strangers.

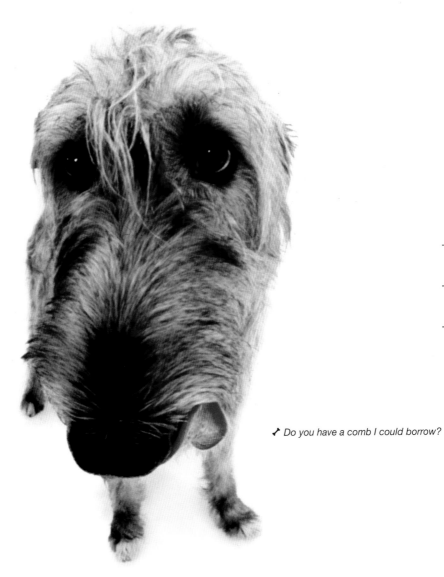

15

🦴 *Do you have a comb I could borrow?*

♪ I'm not letting him play until he takes off that stupid coat.

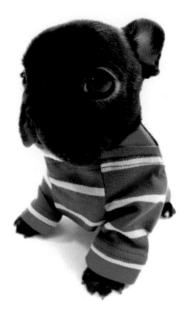

FRENCH BULLDOG

If ever there was a dog with a colourful past it is the "Frenchie". These miniature Bulldogs were never actually used for the despicable sport of bull baiting but were bred from the smaller "runts" of English Bulldog litters by those who found the little dogs adorable. English lace makers are thought to have taken the dogs to France with them when they travelled there in search of work in the middle of the nineteenth century and the breed grew in popularity, becoming quite notorious when they were adopted as pets by Parisian "ladies of the night". Ooh la-la!

🦴 *Being French, we do have
a certain style, non?*

BASENJI

Basenjis are one of the most ancient of dog breeds; images of dogs very much like the Basenji have been found in Egyptian tombs and wall drawings dating from 5000 years ago. They are also known as the Congo Dog because in Africa the breed was used by natives as forest guides and for driving game into nets.

Basenjis are angular and muscular dogs, with short hair and curly tails. They have two outstanding characteristics which set them apart from every other dog breed: firstly, they do not bark but make a variety of other noises instead – they can yodel ("baroo"), grunt and howl, depending on their mood. Their second unusual trait is that they can clean themselves like a cat.

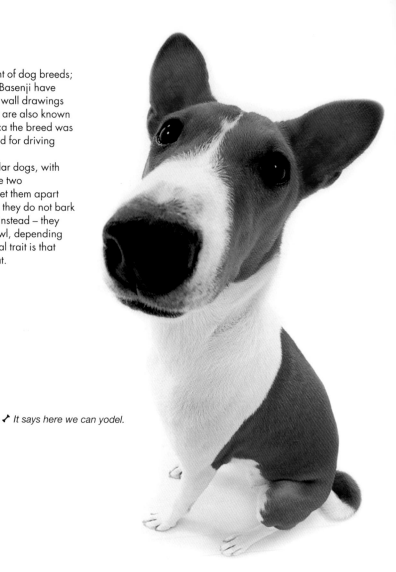

🦴 *It says here we can yodel.*

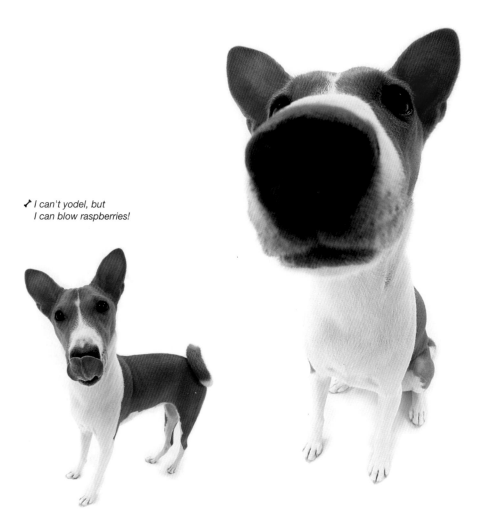

♪ *I can't yodel, but
I can blow raspberries!*

PORTUGUESE WATER DOG

The Portuguese Water Dog is best known these days as being the presidential dog of choice – US President Barack Obama's "First Puppy" is a Portuguese Water Dog called Bo. Originally from the Algarve in Portugal, the Cao de Agua (water dog) was bred by fishermen to herd fish into nets, retrieve lost fishing gear and carry messages from ship to shore.

Portuguese Water Dogs are highly intelligent, have curly coats and webbed toes for swimming. Because of the non-shedding properties of their coat they make good pets for anyone who suffers from dog allergies. Whether kept as pet or working dog, these animals still love the water and like nothing better than going for a swim.

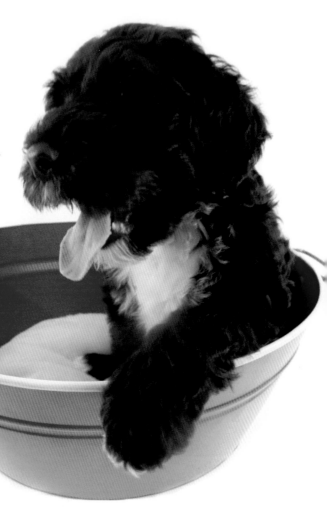

🦴 *So when do we get to meet the President?*

🦴 Are you the President?

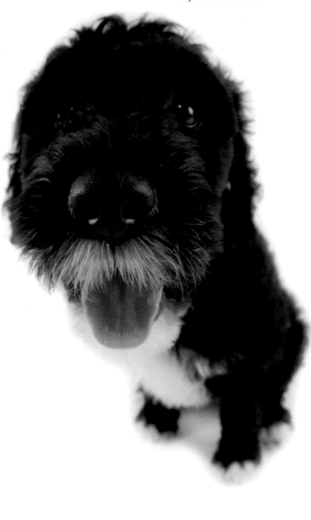

🦴 What's a President anyway?

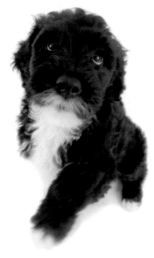

🦴 *I'm a water dog, okay? So where's the water?*

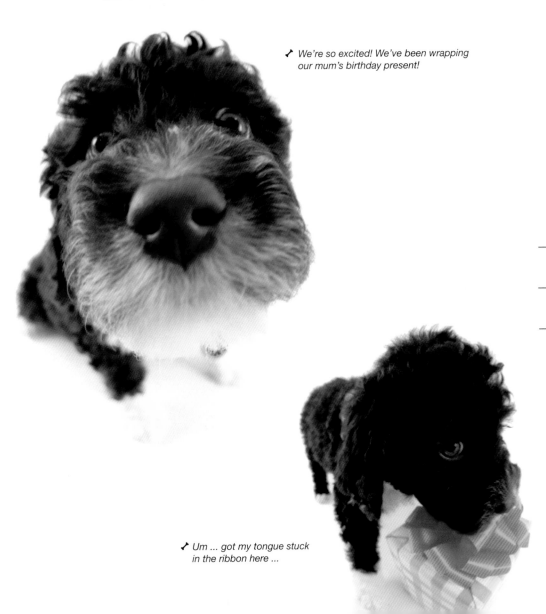

🦴 *We're so excited! We've been wrapping our mum's birthday present!*

🦴 *Um ... got my tongue stuck in the ribbon here ...*

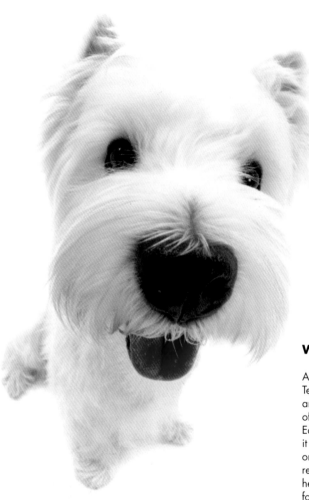

WEST HIGHLAND WHITE TERRIER

As its name suggests, the West Highland White Terrier is all-white in colour, except for its nose and eyes, and comes from the West Highlands of Scotland, where it was bred by Colonel Edward Malcolm of Poltalloch. Legend has it that Colonel Malcolm decided to breed only white terriers after his favourite dog, a reddish brown terrier, emerged from the heather during a hunt and was shot in mistake for a fox. Once widely used to hunt vermin, otters and foxes, the "Westie" achieved worldwide fame alongside the Scottish Terrier when both were used to advertise a famous blend of Scotch whisky.

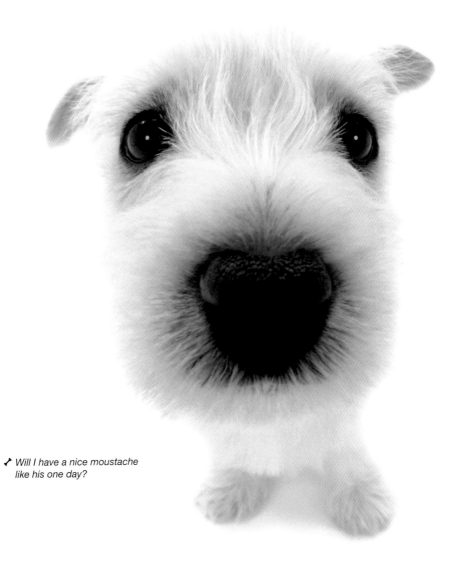

♪ *Will I have a nice moustache like his one day?*

♪ *... then ye tuck it under yer arm like this and blow into a stick. That's how ye play the bagpipes, laddie.*

♪ *So much to learn ...*

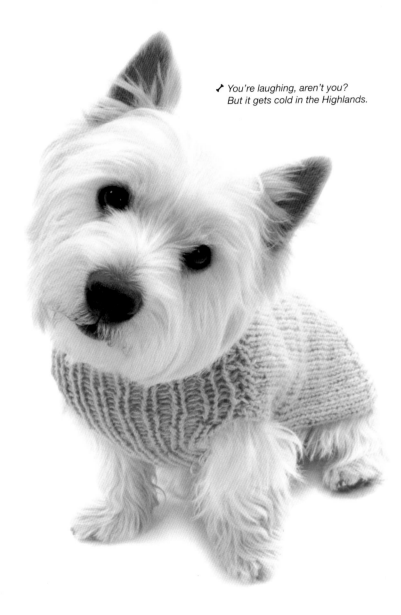

♪ *You're laughing, aren't you?*
But it gets cold in the Highlands.

GREAT DANE

The Great Dane is one of the largest working dogs – the Irish Wolfhound is generally taller but, with its impressively powerful build, the Great Dane is far more solid than the Wolfhound. Despite their huge strength, Great Danes are far from being ferocious and are regarded as the gentle giants of the canine world.

Although the breed is thought to have originated in Germany (primarily for boar hunting), archaeologists have discovered drawings of dogs that resemble Great Danes on Egyptian monuments from 3000 BC, while huge dog skeletons have been found in Viking graves.

According to Guinness World Records, the tallest dog ever was a Great Dane named Shamgret Danzes, who stood 108 centimetres (42.5 inches) at the shoulder, but undoubtedly the most famous Great Dane in recent years is television's cartoon mystery hound Scooby Doo!

28

✔ *Scooby who?*

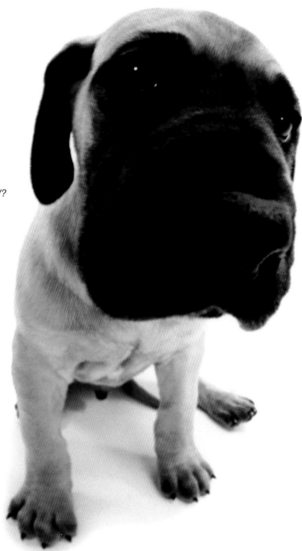

🦴 *And he solved mysteries on TV?
You're kidding me, right?*

29

30

PETIT BASSET GRIFFON VENDÉEN

The Petit Basset Griffon Vendéen belongs to the hound family and originates from the Vendée in Western France. Today they are still used in hunting, either individually or in packs, where they can indulge in a fine vocal performance when on the scent of a boar or hare.

Petit Basset Griffon Vendéens should be twice as long as they are tall, and are small, lying low to the ground. They are not naturally obedient and love to run, so will take off down the road and beyond if an owner is foolish enough to leave a gate open or a hole in the fence unattended. Because of their strong hunting instincts and fondness for picking up scents, they are not ideal city pets.

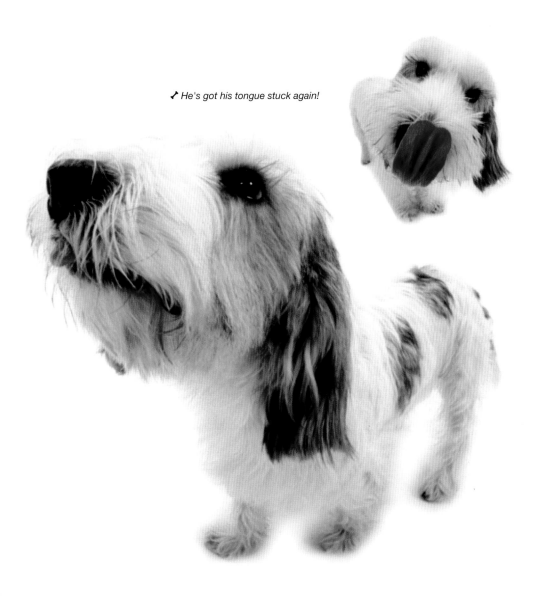

♪ *He's got his tongue stuck again!*

♪ *I think I'm having a bad nose-hair day.*

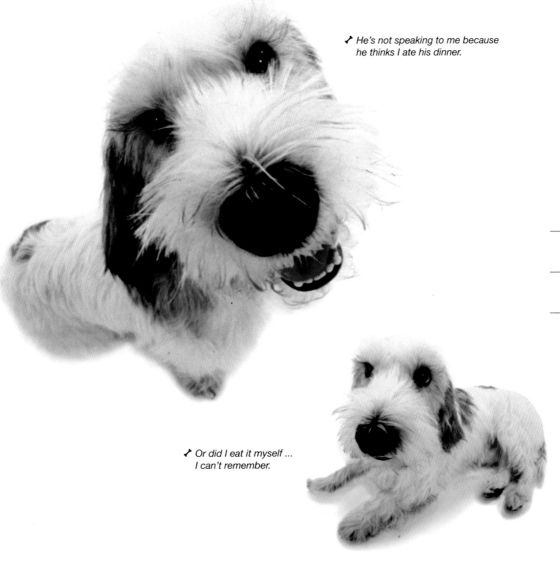

♪ He's not speaking to me because
he thinks I ate his dinner.

♪ Or did I eat it myself ...
I can't remember.

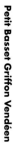

33

GORDON SETTER

The Gordon Setter is the lesser-known relative of the Irish and English Setters. Originally bred to hunt game birds, Gordon Setters still retain their strong hunting instinct and when following a scent they are oblivious to any danger to which they may be exposed – such as oncoming traffic.

Because of their distinctive colouring, Gordon Setters are also known as "Black-and-Tans", acquiring the name "Gordon" in 1924 due to the fact that these black-and-tan dogs were famously bred at the kennels of Alexander Gordon, 4th Duke of Gordon (1743–1827).

Today Gordon Setters are still used as gundogs and because of their affectionate nature they also make loving pets.

Guess which paw the dead slug's under.

♪ *I'm so bored my tongue's dropped out.*

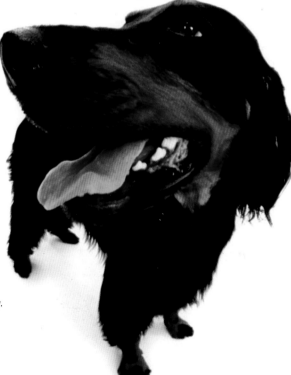

♪ *Me, too. Let's go hunt something.*

JACK RUSSELL TERRIER

The Jack Russell Terrier takes its name from the flamboyant Reverend John Russell, nicknamed "The Hunting Parson", who bred his terriers for fox hunting in Devonshire, England, in the nineteenth century. The Jack Russell ran with the pack hounds but had the specific job of going to ground and flushing out the fox if it tried to take refuge underground. As a working dog, the Jack Russell has also been used for hunting smaller prey, notably rats. Predominantly white with tan or black and tan markings, the Jack Russell has become increasingly popular as a pet. The Reverend Russell would surely have been proud!

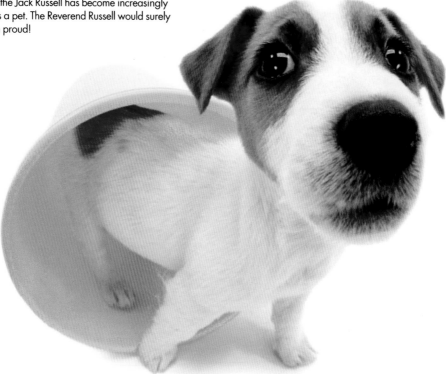

You won't tell anyone you caught me asleep in a bucket, will you?

🦴 *If you don't tickle my tummy,*
I'll make him cry.

🦴

37

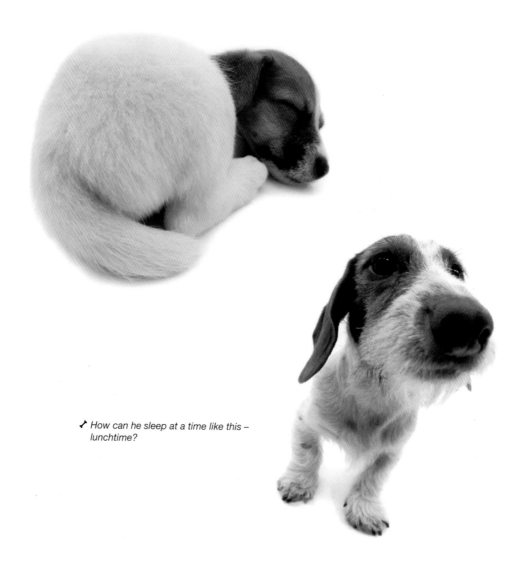

♪ How can he sleep at a time like this –
lunchtime?

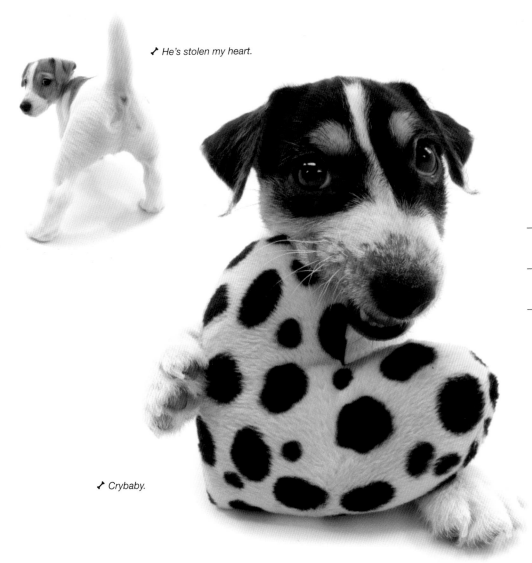

♪ *He's stolen my heart.*

♪ *Crybaby.*

39

MALTESE

Once prized for its prowess as a rat catcher, the tiny Maltese was one of the first of the "Toy" breeds to be introduced into Europe, after which it became more of a ladies' companion and fashion accessory than a working dog. As its name suggests, it is generally accepted that the breed originated on the Mediterranean island of Malta, although it probably arrived there from North Africa around 2,000 years ago, and some argue that it actually came from Sicily. Whatever its ancestry, the modern-day Maltese is a lively, fun dog, good with children and a wonderful family pet, though its very long lemon-white coat does require extensive daily grooming.

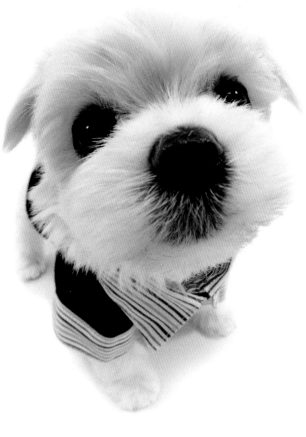

✓ *When he said he wanted a new collar ...*

♪ *I think my tail's exploded.*

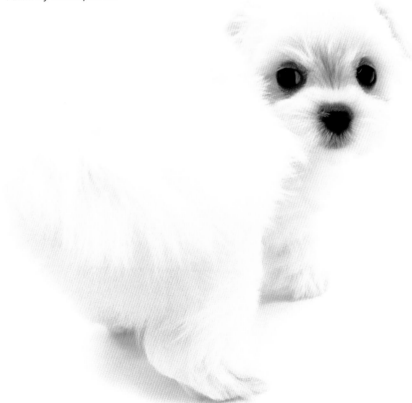

41

*♪ Do you seriously expect me to eat
a biscuit as big as my head?*

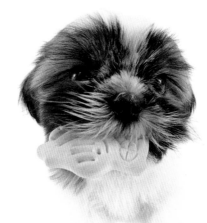

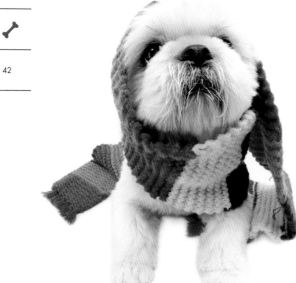

*♪ Does it come in another colour – and
maybe a bit shorter?*

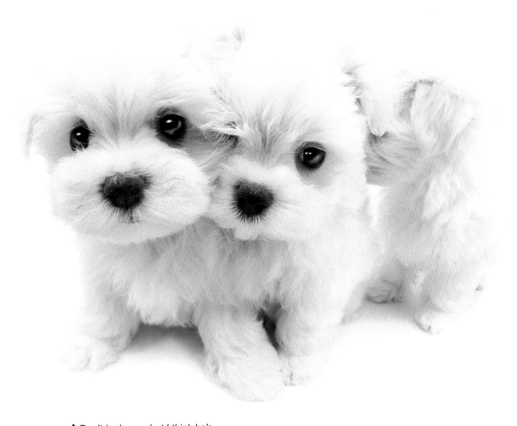

♪ *Don't look now, but I think he's
still following us.*

BEAGLE

Known as the smallest of the British scent hounds, the Beagle's ancestors probably came to England with William the Conqueror in 1066. Ideal for tracking hares or rabbits, they normally worked in packs. Smaller Beagles – called Pocket Beagles – were often carried in hunters' saddlebags and were kept as working dogs until the early twentieth century. The Beagle's coat is usually a combination of black, tan and white, and its white-tipped tail stands up as resolutely as its ears flop down. Alert and energetic, Beagles are remarkably affectionate and playful compared to some working breeds, making them fun to have around.

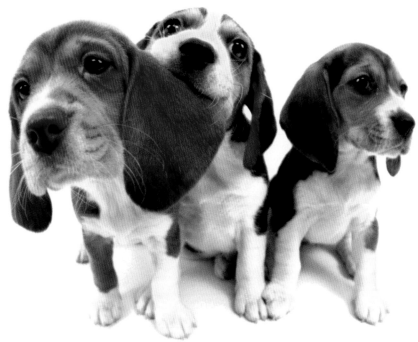

If I do this it looks like I've got a massive tongue!

44

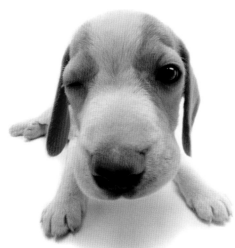

♪ *Don't you just hate it when only half of your face wakes up in the morning?*

♪ *Does my tail look big in this?*

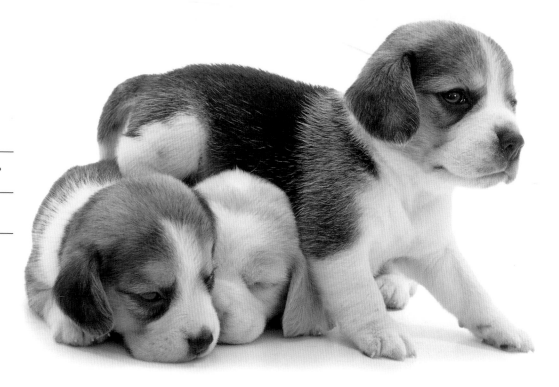

I'm not sitting on them. They both rushed in there when I wasn't looking.

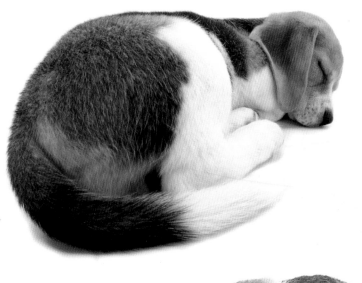

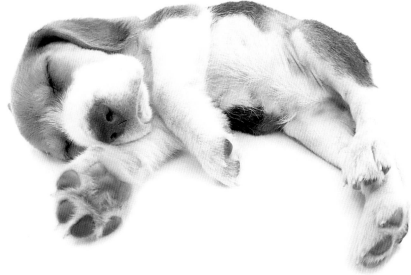

♪ *Let's go for a walk. We could follow the yellow brick road.*

CAIRN TERRIER

The Cairn Terrier, as its name suggests, comes from the Highlands of Scotland where it was bred for hunting and burrowing, mainly for smaller rodents such as rats, squirrels and rabbits, although it was also used for hunting larger prey such as foxes. If kept as a pet – beware! The instinct to dig is strong in the Cairn Terrier and often they perform the same duties as your pet cat, bringing home mice and voles from the garden.

Undoubtedly the most famous Cairn Terrier in history has to be Terry, who played Toto, Dorothy's dog, in the 1939 film *The Wizard of Oz*. And in literature the Cairn Terrier can boast of another famous son – *Greyfriars' Bobby*. TV presenter Paul O'Grady's Cairn Terrier, Olga, makes frequent appearances on his show and his production company is named after her.

49

🦴 *Yikes! It was dark in there!*

GERMAN SHEPHERD

One of the world's most famous and popular breeds, the German Shepherd only came into being a little over 100 years ago. A German enthusiast, fascinated with the intelligence, strength and agility of the country's native sheep dogs, established the breed, which spread throughout the world when Allied soldiers saw how the Germans used them as messenger, tracker and guard dogs during World War I. After the war, the name German Shepherd Dog (*Deutsher Shaferhund*) was dropped in favour of the Alsatian Wolf Dog (after the Alsace-Lorraine German/French border region), as it was thought that the word "German" would make the breed unpopular, and Alsatian continued to be used for the breed until the 1970s.

... and if I tilt my head like this, it looks like I've just eaten a smaller dog.

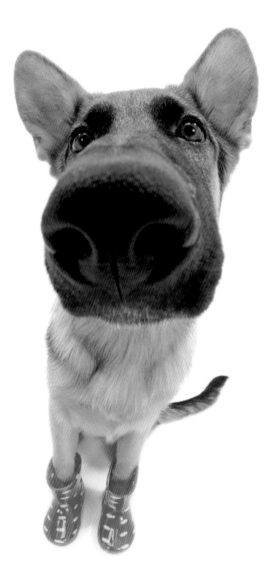

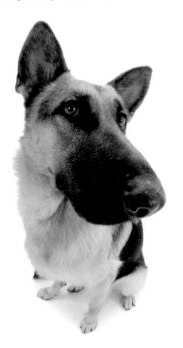

🦴 *He's getting too big for his boots.*

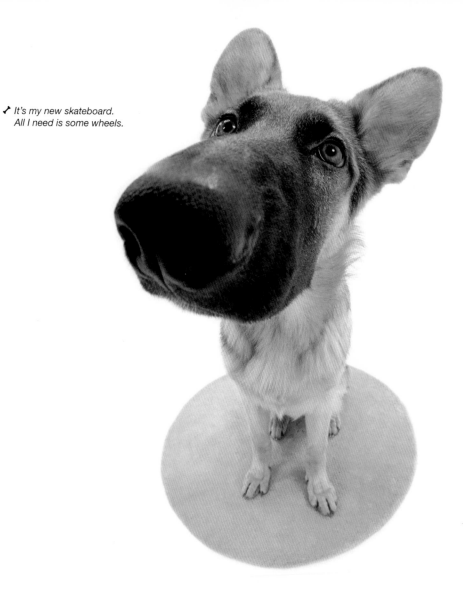

♪ *It's my new skateboard.*
All I need is some wheels.

52

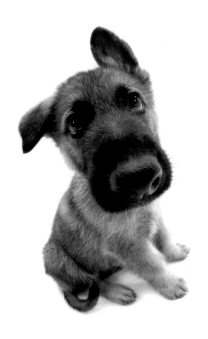

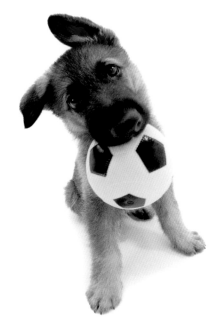

53

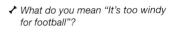 *What do you mean "It's too windy for football"?*

FLAT-COATED RETRIEVER

These attractive and affectionate dogs were developed as working gun dogs in Britain and used extensively until the 1920s, when Labradors and Golden Retrievers started to become more popular. Although British, their ancestry lies on the other side of the Atlantic in North America, where they are believed to have been bred from the Labrador and the Newfoundland with a trace of Setter also in their bloodline. Black or liver in colour, the Flat-Coated Retriever is easy to train and, as you might expect from a retriever, it loves water and is an excellent swimmer.

✗ *Yes, it's a nice colour, but it's not very flat, is it?*

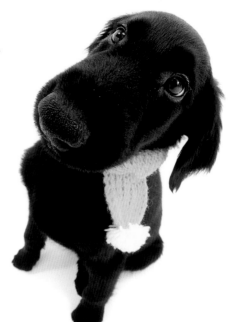

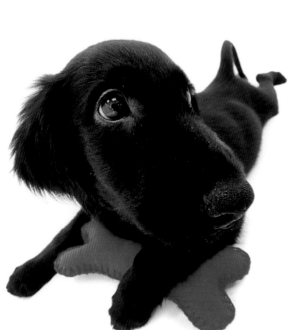

I think I just swallowed one of Santa's little helpers.

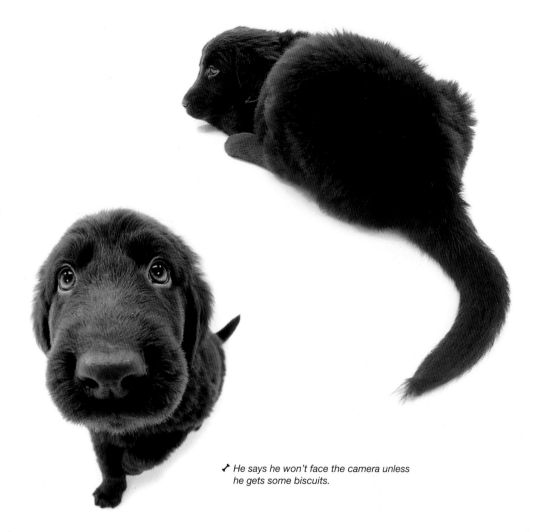

♪ *He says he won't face the camera unless he gets some biscuits.*

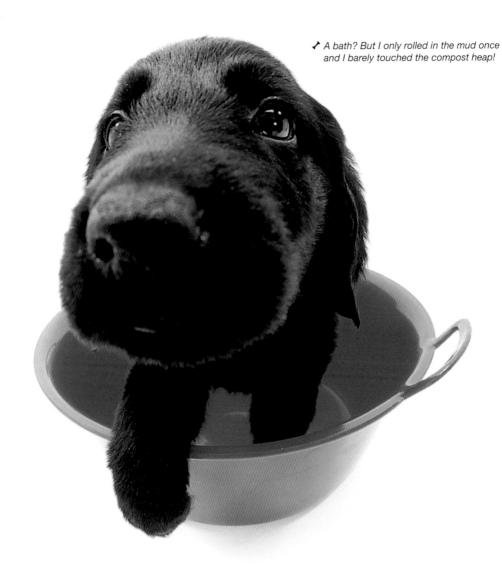

🦴 *A bath? But I only rolled in the mud once and I barely touched the compost heap!*

SCHNAUZER

The Schnauzer comes in three sizes – Minature, Giant and Standard. The Standard Schnauzer originated in Germany, near the French and Swiss borders, where they were used for exterminating rats but later became prized as guard dogs and watchdogs.

Schnauzers have distinctive moustaches and eyebrows, giving them an old-fashioned Germanic look. Their coat is wiry but they have longer hair on their legs.

Intensely loyal dogs, Schnauzers tend to be "one-family" or even "one-man" dogs and do not get on with other family pets unless they have been introduced at an early age. They do, however, make excellent pets on account of their loyalty and willingness to alert the family to any strangers approaching their territory.

♪ *Watch this ... ears up ... it's Batman!*

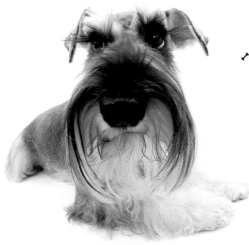

♪ *I've given my nose hair the Jennifer Aniston look.*

♪ *I know I've still got some breakfast up here somewhere ...*

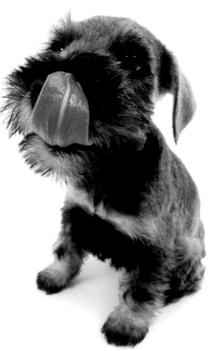

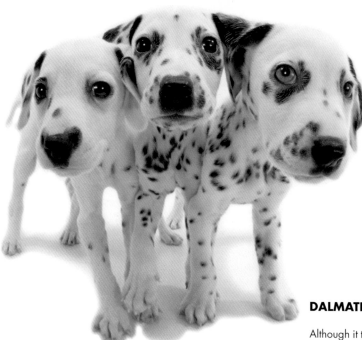

✦ *We like to hold hands in photos.*

DALMATIAN

Although it takes its name from Dalmatia, a region of Croatia, the Dalmatian probably originated in northern India, from where it was brought to Dalmatia by traders. Dalmatians were initially used as watchdogs, but by the time this elegant breed had spread further west, its good looks had turned it into something of a fashion accessory. In the eighteenth and nineteenth centuries, liver-and-white or black-and-white Dalmatians could be seen trotting alongside the carriages of their wealthy owners, ostensibly to ward off attacks by highwaymen, but also for show. Being fashionable also made the Dalmatian one of the most famous breeds in the world, when Cruella De Vil tried to turn 101 of them into a coat in the Disney movie *101 Dalmatians* and its sequels.

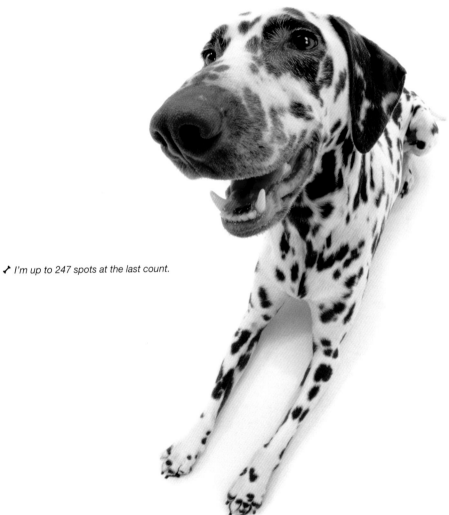

♪ *I'm up to 247 spots at the last count.*

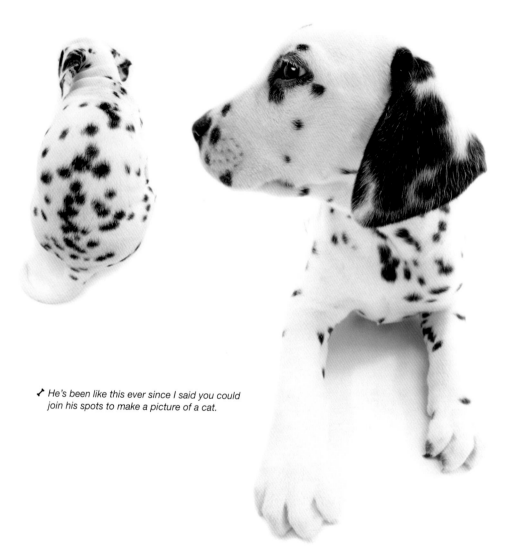

♪ He's been like this ever since I said you could join his spots to make a picture of a cat.

✔ I told you it was a lot bigger inside than it looks.

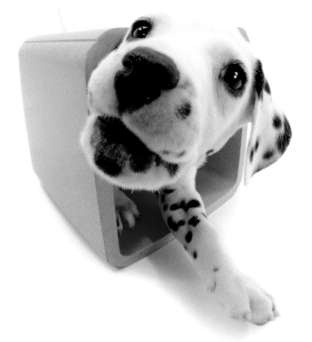

Dalmatian

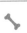

63

SALUKI

Also sometimes known as the Gazelle Hound, the Saluki, like the Afghan and the Greyhound, has its origins as a hunter in the Middle East. The name Saluki probably comes from the Yemeni town of Saluk. For centuries Arab hunters used the Saluki to take gazelle – among the swiftest of antelopes – and held the dogs in such high esteem that to be offered one as a gift was seen to be a great honour. Although the modern Saluki comes in a huge variety of colours, it is nevertheless a most distinctive breed, tall and slim with a coat that is generally short and smooth except for its long ears and tail where the hair is long and silky.

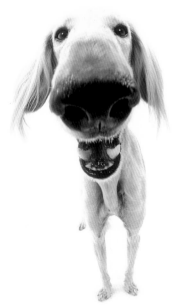

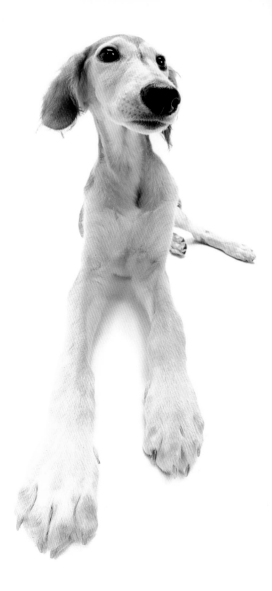

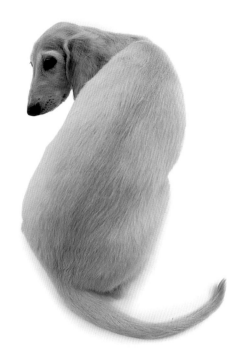

🦴 *Hey! Quit sneaking up behind us!*

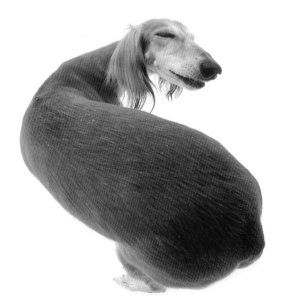

WHIPPET

Whippets are basically small greyhounds and, like greyhounds, although they can be madly active in short bursts they are perfectly content to spend large parts of the day simply resting. They are affectionate, loyal dogs and are well known for their friendly nature – except if you're a cat. Unless a whippet has been raised with cats it will attack them whenever it sees them in its territory.

Whippets are sometimes called "the poor man's racehorse" as they are outstanding running dogs, whether racing at a track or "lure coursing" out in the countryside where the dogs chase a lure across a field.

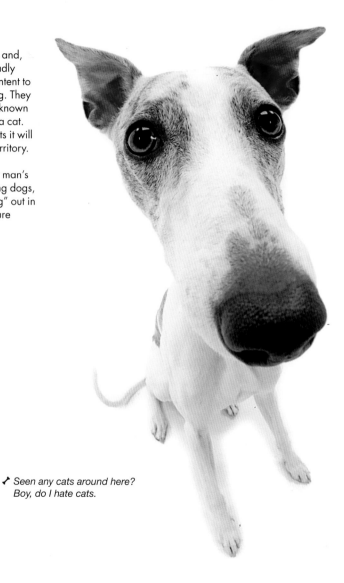

✔ Seen any cats around here? Boy, do I hate cats.

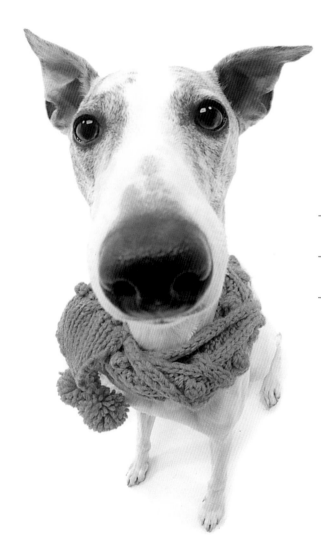

♪ *Take a look at that scarf!*
I thought I looked stupid ...

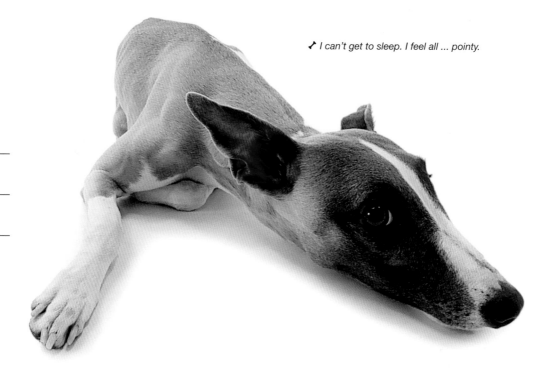

♪ I can't get to sleep. I feel all ... pointy.

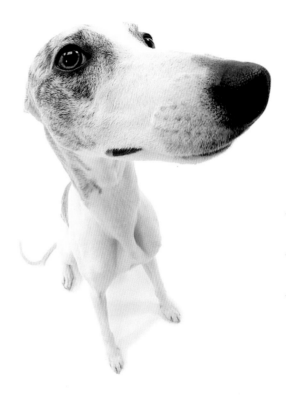

♪ *See that? I think it's a small cat.
We'd better chase it.*

♪ *Okay. No, wait. I think that's what they call a ...
spider.*

♪ He won't let me have a go in the red thing!

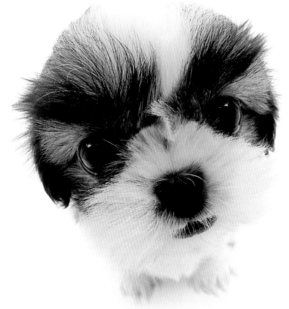

SHIH-TZU

Remarkably similar to the Tibetan Lhasa Apso, the Chinese Shih-Tzu is one of the "Lion Dogs" of the Orient. The lion plays a major role in Buddhist mythology, having been kept as a pet by Buddha himself, and Lion Dogs are thus seen as having a link with Buddha. Developed in Beijing as a result of breeding Chinese and Tibetan types, the little Shih-Tzu has a long wavy coat. The hair around its face and head has been likened to a chrysanthemum flower, which is why the breed is also sometimes called the Chrysanthemum Dog.

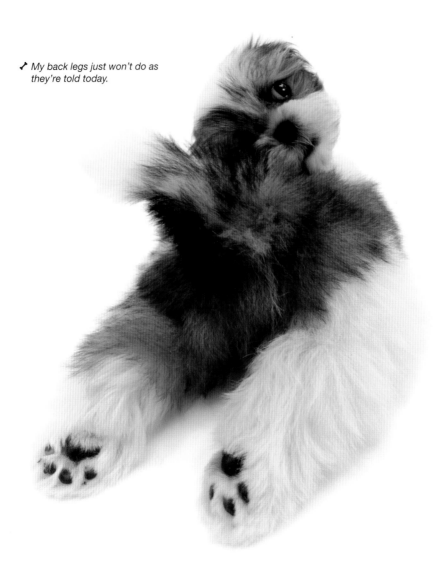

🦴 *My back legs just won't do as they're told today.*

♪ Does this mean we're engaged?

♪ A pillow's never comfy until it's
been properly chewed.

♪ *Why am I wearing a little blue coat?*
 Because pink's for girls.

73

SHETLAND SHEEPDOG

The Shetland Sheepdog has the same attractive face and glamorous coat as the Rough Collie, except that all those good looks come in a much smaller package. Just 60 per cent of the size of a Rough Collie, the Shetland nevertheless was a very effective working dog. It was bred in the eighteenth century in the Shetland Isles off the north coast of Scotland, not only for herding sheep but also for controlling the native ponies and even chickens. Lively, intelligent and affectionate, the Shetland is small enough to tolerate life in town, making it an ideal family pet. Its suitability for domestic life has seen its popularity spread around the world, most notably to Japan – a far cry from its beginnings in Scotland's northern isles.

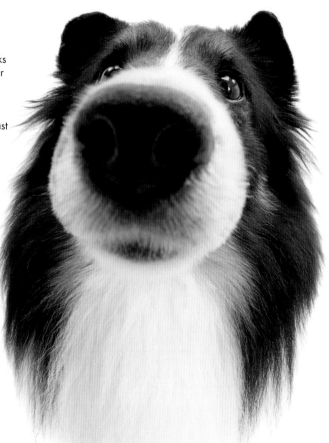

 Hey! I can see myself in your camera thingy.

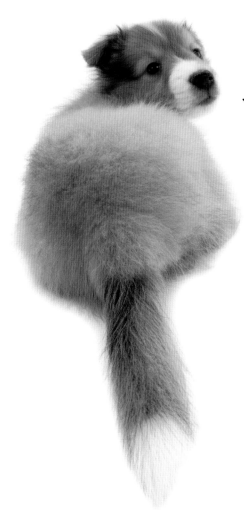

✦ Will that do? It's as straight
 as I can get it.

✦ So how many miles to the gallon do you
 get in one of these?

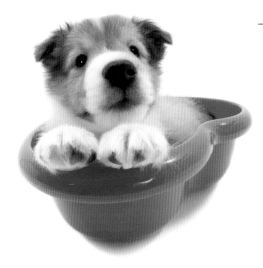

♪ *I knew I'd make the formation snoozing squad one day.*

♪ *If I listen hard enough, I can hear him thinking about how annoying I am.*

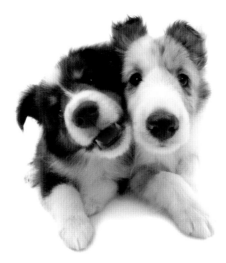

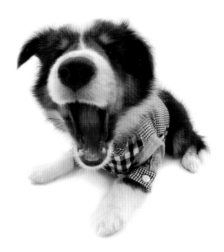

♪ *Yawn! PJs on – time for bed.*

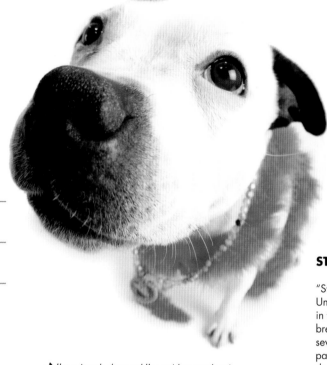

♪ I'm a tough dog and I'm not happy about the pink – but can I keep the beads?

STAFFORDSHIRE BULL TERRIER

"Staffies" are enormously popular in both the United Kingdom and the United States, featuring in the Top 10 of both countries' most favoured breeds. The breed was developed in seventeenth-century England as part bulldog and part terrier. The result was a stocky, muscular dog with enormous strength, tenacity and agility. Back then, the dogs were a truly egalitarian breed, owned by the wealthy, aristocratic ruling class and the far less affluent working class – the steelworkers, miners and chainmakers of Staffordshire, from where the breed's name eventually derived.

Today the Staffie is best known for its courage, intelligence and affectionate nature. It is often said that no breed is more loving with its family than a Staffie, and they make truly excellent companions.

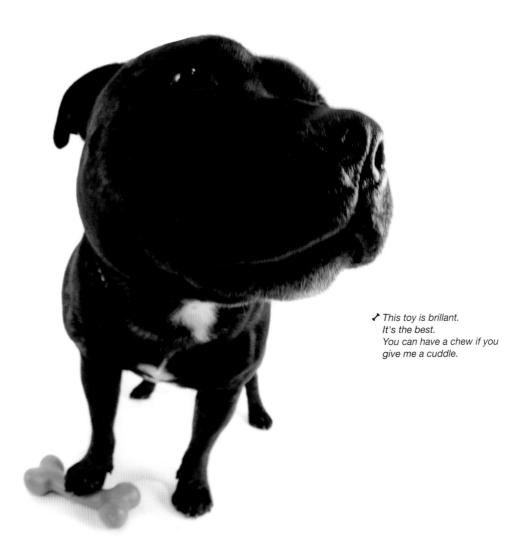

This toy is brillant.
It's the best.
You can have a chew if you
give me a cuddle.

AMERICAN COCKER SPANIEL

The differences between the American and English Cockers first became apparent in the 1920s, although the American Cocker Spaniel was not recognized as a distinct breed until 1946. It has a much longer coat than its English cousin, and a longer neck, although overall it is slightly smaller in stature. American Cocker Spaniels, like their English relatives, are hugely popular as pets because they are very willing and easy to train, but their coats do require extensive grooming.

Oops! Runny nose. Best catch that. Don't want to look silly in the photo.

🦴 *Try putting me in a dress like that
and you'll be missing a few fingers!*

♪ And you said I'd never fit ...

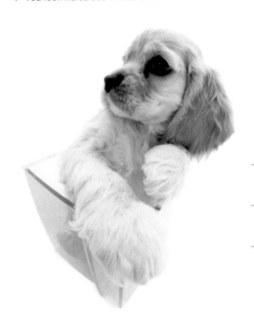

♪ You look ridiculous in that dress.

♪ At least I'm not wearing the box it came in.

ENGLISH BULLDOG

Originating in the sixteenth century in England, English Bulldogs were bred for bull baiting, a barbaric sport that involved tethering a bull and setting dogs on it. The dogs would latch on to the poor animal, while it would attempt to gore or toss the dogs. The Bulldog was particularly tenacious, the shape of its jaw allowing it to lock on to its prey yet still breathe normally. Bull baiting was banned in England in 1835 and today the Bulldog breed is far less aggressive, although it is still known for its stout-heartedness and tenacity.

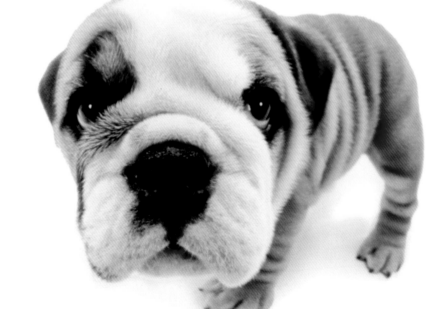

I know I look glum, but I'm really quite a cheerful chap.

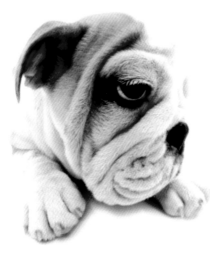

🦴 *One day, when I'm bigger,
my coat will fit properly.*

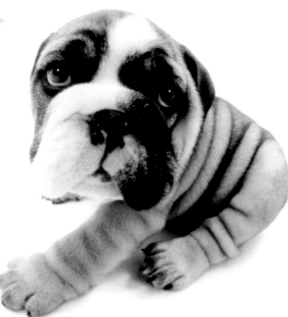

🦴 *Sometimes it all just sort of slides
towards the back end.*

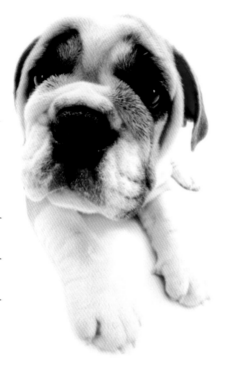

♪ *I use a lot of energy*
 just raising my eyebrows.

♪ *Lifting a whole ear*
 completely wears you out.

♪ *I may be a tough guy,*
but I still like a cuddle.

♪ *My face fell into my dinner today.*

CURLY-COATED RETRIEVER

The Curly-Coated Retriever is one of the oldest Retriever breeds, and because of its uniquely textured, curly, water-resistant coat, it is also one of the most distinctive. The dogs are usually black or liver brown and because of their good looks, in the 1800s they were the most popular Retriever breed in Britain. They were nicknamed "blue collar Retrievers" because a curly was more likely to be owned by a gamekeeper or poacher than the lord of the manor.

Nowadays the Curly-Coated Retriever makes a fine family pet although it does require plenty of exercise to stop it becoming bored and misbehaving – and of course they are great natural swimmers so it's very hard to keep them out of the local pond!

♪ Ah, that's better! Just managed to tip the last few dribbles of pond water out of my ear.

🦴 *We just want to say that it wasn't us who jumped up on the table and ate the delicious cake that sticks to the roof of your mouth a bit ...*

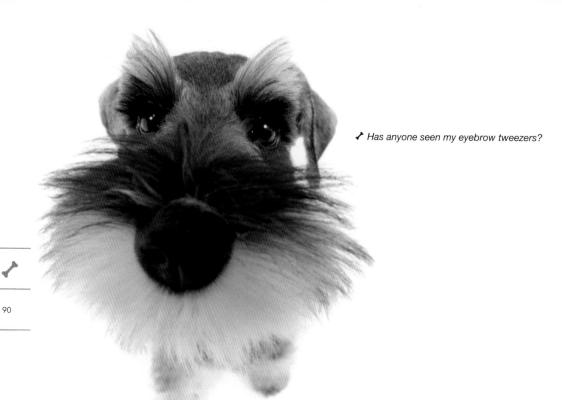

♪ Has anyone seen my eyebrow tweezers?

MINIATURE SCHNAUZER

The Miniature Schnauzer is the result of a cross between the Standard Schnauzer and smaller breeds of dog. It was bred to hunt rats and, like many other "ratters", the whiskery Miniature Schnauzer, also called the Zwergschnauzer, is classed as a Utility dog. Although small, it makes an excellent guard dog and family pet, but its coat – and especially those whiskers – needs regular trimming and daily grooming.

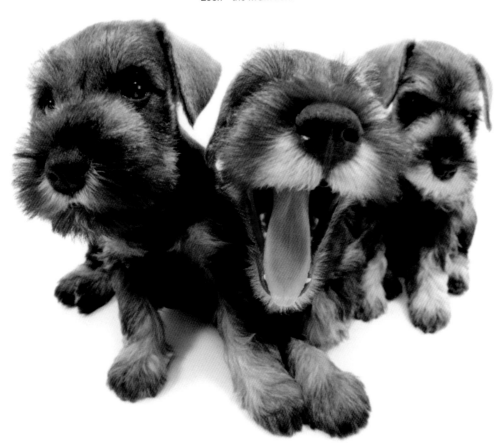

♪ *My brother will now do a movie impression.*
Look – the MGM lion!

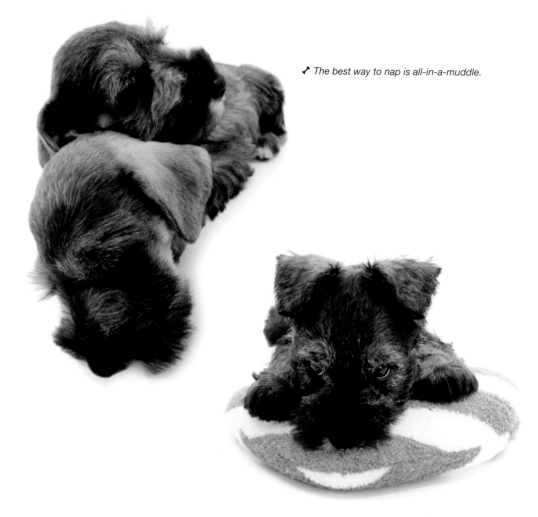

♪ The best way to nap is all-in-a-muddle.

♪ Pillow? So it's not a giant lollipop?

🦴 *Hey! Don't be so rude!*

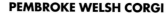

He slept in this morning, so I got to wear the coat.

PEMBROKE WELSH CORGI

Corgis are known to have existed in Wales for almost a thousand years. They are said to have been introduced by Flemish weavers who settled in the Welsh valleys in the early 1100s, although some believe the little dogs may have been in Wales far longer. Corgis could be related to Swedish Vallhunds and may have been brought to Wales by Viking raiders in the ninth century, or they may have arrived with Celtic travellers even earlier. Whatever their ancient history, the two different Corgi types are now firmly established as Welsh breeds. The Pembroke is the smaller of the two – the other being the Cardigan Welsh Corgi; it has only a short tail by comparison, and is famous for enjoying royal patronage as the favourite pet of Queen Elizabeth II.

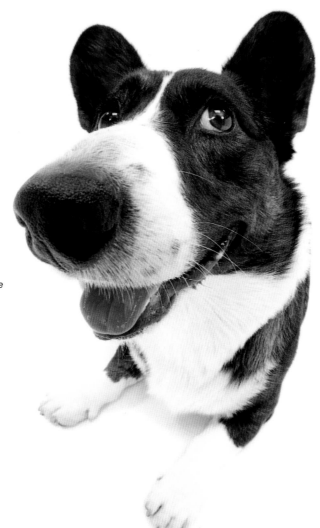

🦴 *I bet you'll never guess where I've buried your car keys.*

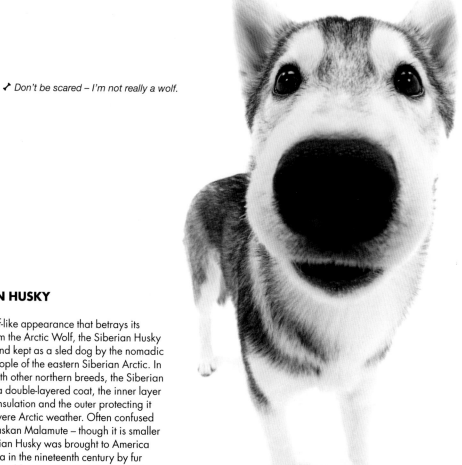

♪ Don't be scared – I'm not really a wolf.

SIBERIAN HUSKY

With a wolf-like appearance that betrays its descent from the Arctic Wolf, the Siberian Husky was bred and kept as a sled dog by the nomadic Chukchi people of the eastern Siberian Arctic. In common with other northern breeds, the Siberian Husky has a double-layered coat, the inner layer providing insulation and the outer protecting it from the severe Arctic weather. Often confused with the Alaskan Malamute – though it is smaller – the Siberian Husky was brought to America and Canada in the nineteenth century by fur traders and gold prospectors who ventured into Asia. Some dogs in this energetic outdoors breed have amazing eyes of the brightest blue.

🦴 *These hats are very fashionable in Siberia.*

🦴 *… 18 … 19 … I'm trying to break the record for the number of times I can roll over without being sick.*

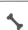

97

POODLE

Descended from much larger French and German hunting dogs more than 500 years ago, modern Poodles are found in three different sizes: the Standard Poodle, Miniature Poodle and Toy Poodle. Their coats do not moult so they need to be trimmed regularly. Although the remarkable "pom-pom" trim is now purely for decoration or show, working Poodles were originally clipped in this way to keep their ankles warm and to trap air around their chest, which helped them to stay dry and warm when retrieving game from rivers or lakes. The rest of the coat was clipped short to aid mobility in the water. Poodles became the height of fashion as pets in the 1950s, when the Miniature Poodle became the world's most popular breed.

… then I stuck my ears out like this and the wind blew me over!

♪ *Be honest … orange doesn't suit me, does it?*

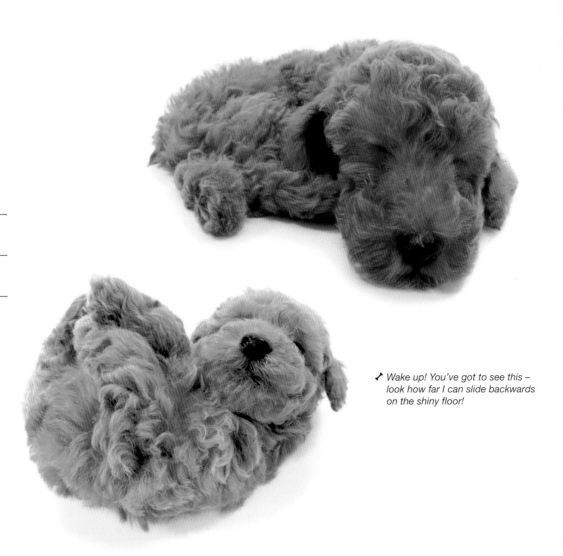

🦴 *Wake up! You've got to see this –*
look how far I can slide backwards
on the shiny floor!

🦴 *He's a bit upset because I can spin round to catch my tail and he can't. He's been trying all morning.*

♪ *Let's see, that's K-O-O-K ... no?*
Oh, I'll never get the hang of spelling it!

KOOIKERHONDJE

Probably the most difficult dog breed to spell, the Kooikerhondje's name is Old Dutch for "Small Dutch Waterfowl Dog". Traditionally used for luring ducks into traps, as well as catching rats and mice, this breed originated in Holland and holds a special place in the hearts of Dutch people. The life of Prince William II of Orange was saved by his faithful Kooikerhondje, who woke him in the night during an assassination attempt.

The Kooikehondje has also featured in paintings by the Dutch Old Masters of the sixteenth and seventeenth centuries. It is an extremely pretty little dog with distinctive black "earrings" which distinguish it from others in the spaniel family.

✦ *We saved the prince's life?*

✦ *Do we get a biscuit for that?*

BOXER

Fearless, strong and loyal, the Boxer is highly respected as a guard dog and is used for police work in some countries, although its adaptable and responsive nature has also allowed it to take on the role of guide dog. Descended from Bullenbeisser Mastiffs and Bulldogs from Munich in Germany around 150 years ago, the Boxer was originally intended for bull baiting and boar hunting. Despite its aggressive image, the Boxer makes an excellent family pet. Its short, glossy, fawn-and-white coat requires little grooming but Boxers do need lots of exercise and attention.

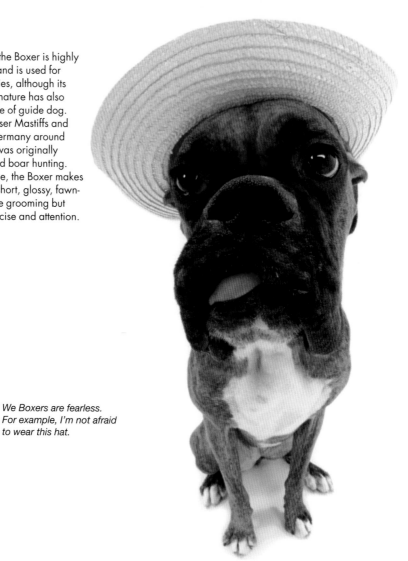

✔ *We Boxers are fearless. For example, I'm not afraid to wear this hat.*

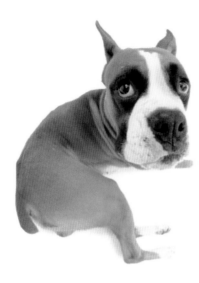

♪ *Oops! He's down ... the same thing happened to him on the ice on the local pond.*

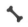

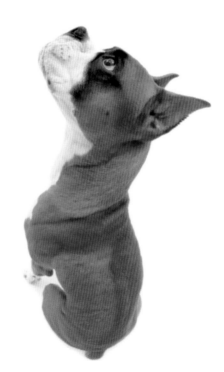

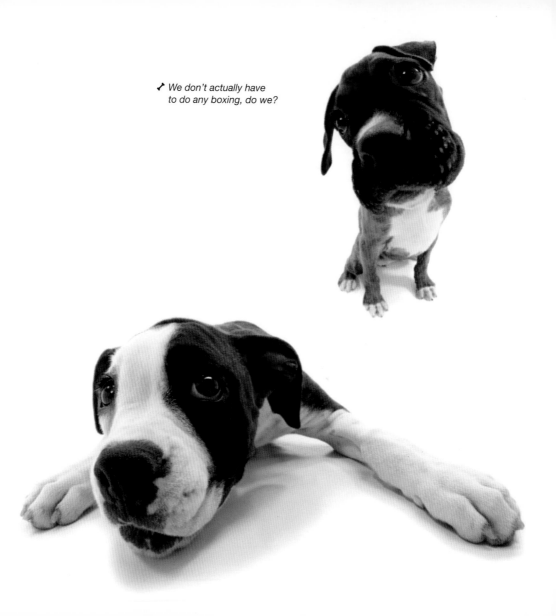

🦴 *We don't actually have to do any boxing, do we?*

107

🦴 *This is the paw you stepped on,
but I'll forgive you if you give
me a cuddle.*

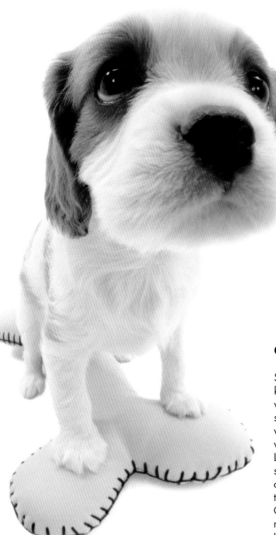

♪ *Don't you dare take my bone away,*
or I'll ... I'll ... cry.

CAVALIER KING CHARLES SPANIEL

Small dogs kept as pets or companions and known as "Toy" dogs became extremely popular with European nobility in the sixteenth and seventeenth centuries. The King Charles Spaniel was the favourite of the English King Charles II, who used to walk his dogs in St James's Park in London. Over the years the breed developed a shorter, snub nose, but in the early twentieth century efforts were made to take the breed back to its royal roots, and in 1928 the longer-nosed Cavalier King Charles developed. It was registered as a separate breed with the British Kennel Club in 1945.

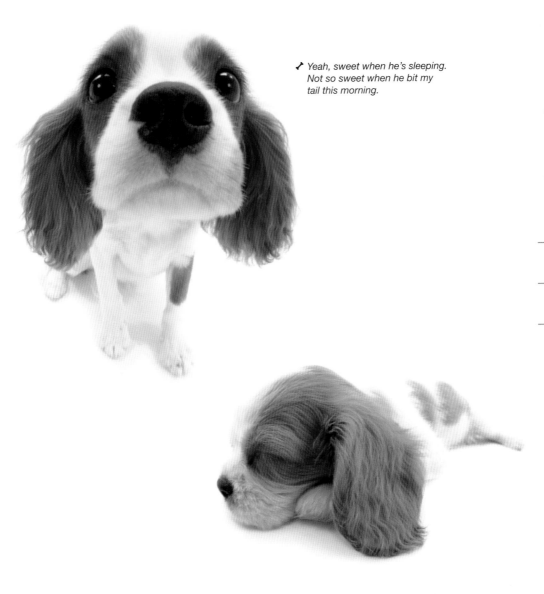

🦴 *Yeah, sweet when he's sleeping. Not so sweet when he bit my tail this morning.*

109

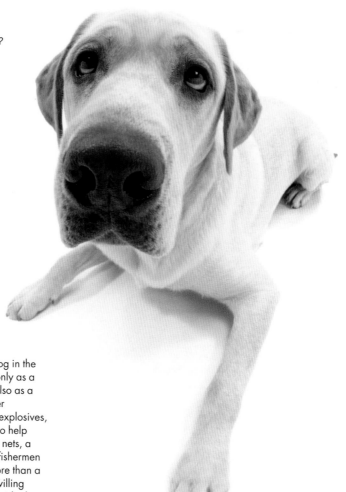

*♪ Yes, I had triplets. Three boys.
I can't tell them apart, can you?*

LABRADOR RETRIEVER

Probably the most versatile working dog in the world, the Labrador is employed not only as a gun dog for retrieving wild fowl, but also as a sniffer dog with police forces and other emergency services, detecting drugs, explosives, contraband and even people. It used to help Newfoundland fisherman haul in their nets, a task that it also performed for English fishermen when it was first brought to Europe more than a century ago, and its friendliness and willing nature have made it a favourite as a guide dog for the blind. The Labrador Retriever is most popular of all, however, as a loving family pet.

♪ *Ooooh ... when you yawn like that I can
see all the way down to your breakfast.*

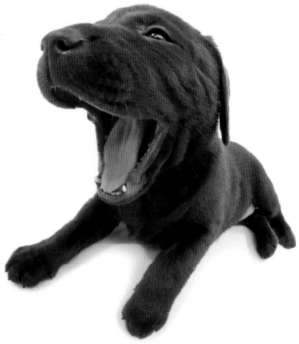

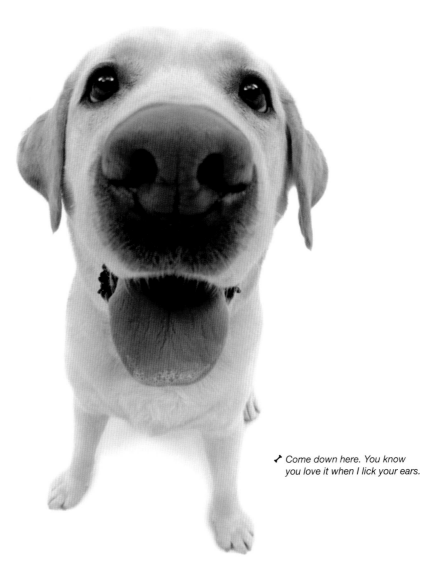

Come down here. You know you love it when I lick your ears.

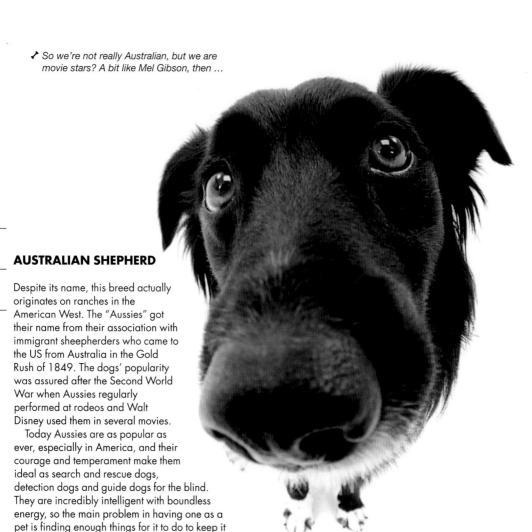

So we're not really Australian, but we are movie stars? A bit like Mel Gibson, then …

AUSTRALIAN SHEPHERD

114

Despite its name, this breed actually originates on ranches in the American West. The "Aussies" got their name from their association with immigrant sheepherders who came to the US from Australia in the Gold Rush of 1849. The dogs' popularity was assured after the Second World War when Aussies regularly performed at rodeos and Walt Disney used them in several movies.

Today Aussies are as popular as ever, especially in America, and their courage and temperament make them ideal as search and rescue dogs, detection dogs and guide dogs for the blind. They are incredibly intelligent with boundless energy, so the main problem in having one as a pet is finding enough things for it to do to keep it happily active and occupied.

✦ *Scary tongue, isn't it.*
 She uses it to wash my face!

♪ *I don't care what nationality I am,
as long as everyone loves me.*

ENGLISH COCKER SPANIEL

Despite now being known as English Cocker Spaniels – they were called simply Cocker Spaniels until the American Cocker Spaniel was recognized as a separate breed – these dogs probably originated in Spain around 600 years ago. Their nationality is further complicated by the fact that they were developed as gun dogs in Wales, where they were used to flush out and retrieve small game birds in the nineteenth century.

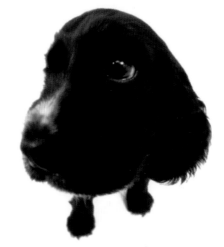

♪ *Look in that field! The biggest dogs you ever saw!*

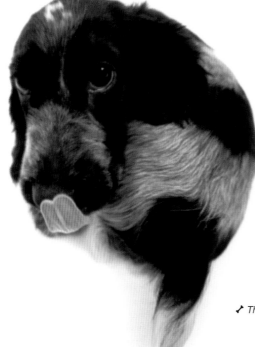

♪ *They're cows, you fool.*

YORKSHIRE TERRIER

Now classed in the "Toy" group, the Yorkshire Terrier was once a working dog employed for one of the most arduous tasks any dog could undertake. The breed was developed by coal miners in the West Riding area of Yorkshire in England during the nineteenth century when they decided that they needed a small dog to take down into the mines with them to kill rats. The "Yorkie" that is so popular as a pet today is far prettier than the dog originally bred by the miners. Show dogs now have a long, silky coat of steel blue and tan that would be totally unsuitable to working down a mine, although Yorkshire Terrier puppies are born coal black!

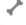

♪ The first one to laugh at the bow gets a poke in the eye.

♪ *I'm not laughing.*
Not a giggle.
Not even a titter.

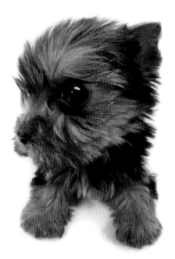

119

♪ *I don't think I can hold in this*
snigger much longer.

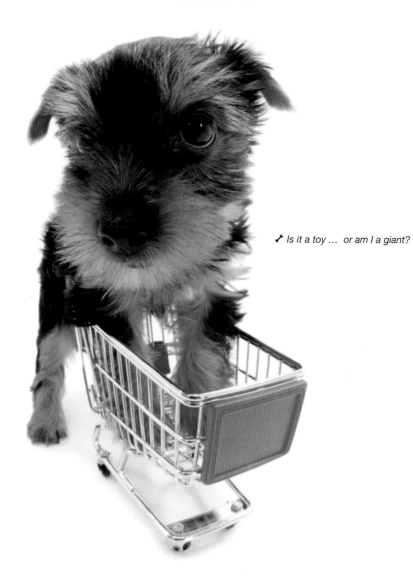

🦴 *Is it a toy … or am I a giant?*

🎵 *He says he can play the piano lying down.*

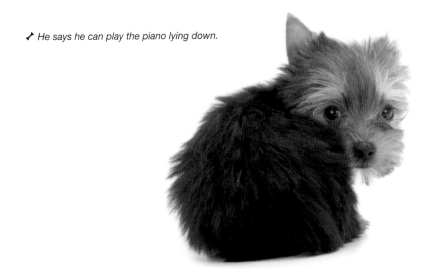

🎵 *I can ... as soon as someone finds me a lying down piano.*

GOLDEN RETRIEVER

Native to Britain, the Golden Retriever is one of the top five most popular breeds in the UK. Bred principally from yellow Flat-Coated Retrievers and Tweed Water Spaniels in the mid-nineteenth century, Golden Retrievers were, of course, intended as gun dogs. Their dense, waterproof coats and long legs make them ideal for bounding into marshland or ponds to retrieve downed game. Although the Golden Retriever is a large and powerful dog, it can gently pick up shot birds, hares or other game in its mouth without damaging its quarry. Their gentle nature has made them incredibly popular as family pets as they are exceptionally good with children.

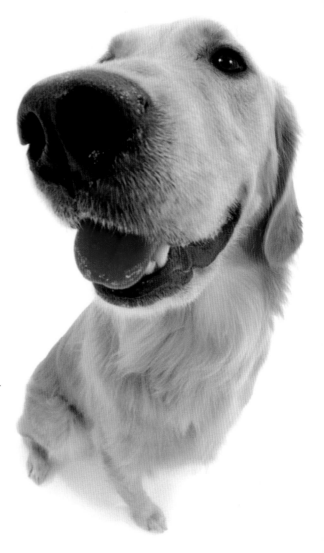

♪ *In the car I stick my head out the window like this … because the music they play is rubbish.*

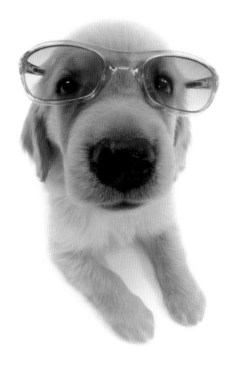

✔ Of course, I don't actually need
to wear glasses. Well, maybe
just for reading.

123

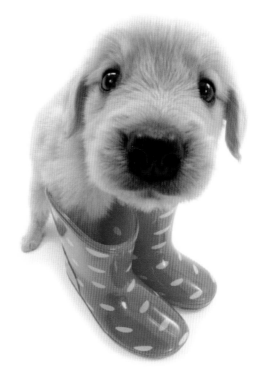

✔ Have you got another pair
the same for my back legs?

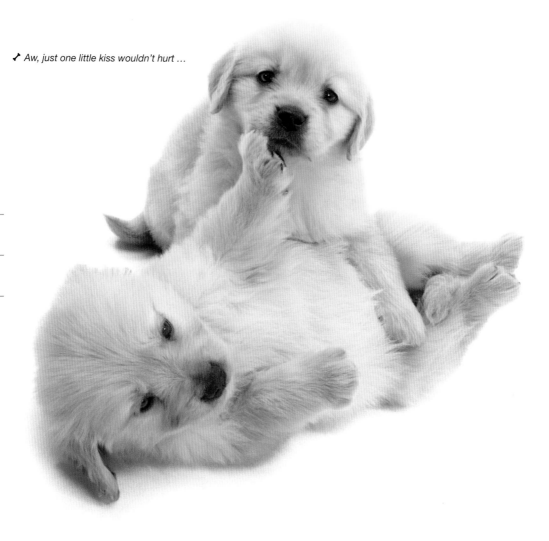

♪ *Aw, just one little kiss wouldn't hurt …*

🦴 *Please, Miss. He's asleep again, so can I have his lunch?*

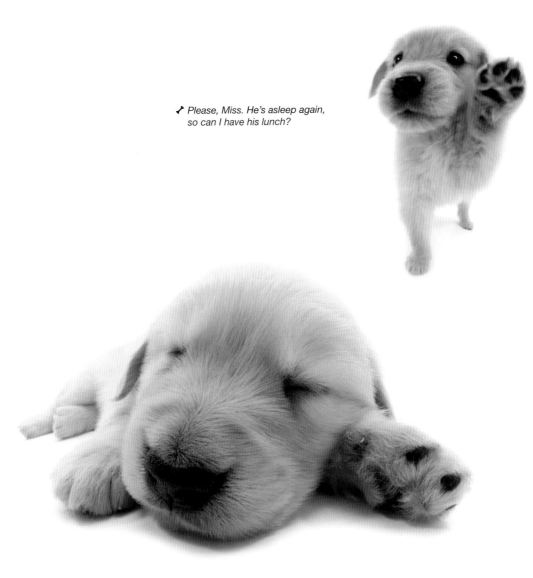

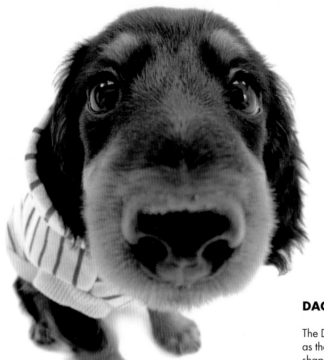

♪ *Do you think that stripes make me look taller?*

DACHSHUND

The Dachshund, sometimes affectionately known as the "sausage dog" because of its elongated shape, is generally thought to have originated in Germany. Dachshund, in fact, means "badger dog" in German and the breed was once used for flushing badgers out of their sets, the Dachshund's shape being ideally suited to scuttling down holes and along tunnels. Some believe, however, that the Dachshund may have a much older ancestry, as a similarly shaped hound has been seen in some Ancient Egyptian carvings. It was first brought to England by Queen Victoria's husband, Prince Albert, in the nineteenth century. The modern Dachshund stands even shorter than its Victorian forebears and has standard, miniature, short, wire and long-haired varieties in most colours.

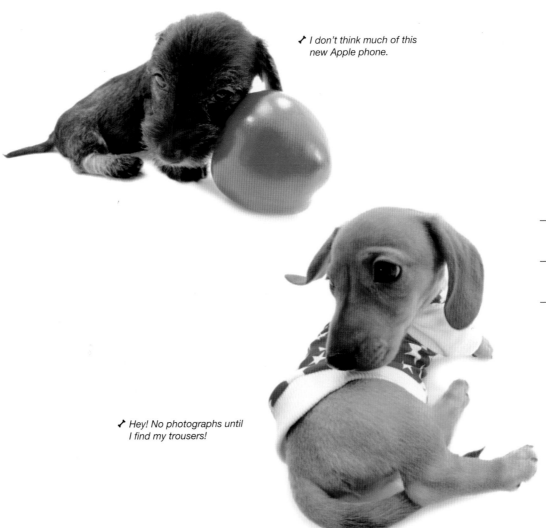

🦴 *I don't think much of this new Apple phone.*

127

🦴 *Hey! No photographs until I find my trousers!*

♪ Modelling's tough at a photo shoot.
Lights! Camera! Snooze …